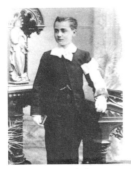

Joan Miró at the age of seven.

Joan Miró (1893–1983) is one of the most significant Spanish painters of our century.

His early work clearly shows the influence of Fauvism and Cubism. The Catalan landscape also shapes the themes and treatment of these initial works. In his travels Miró encountered the intellectual avant-garde of his time. His friends included Francis Picabia, Tristan Tzara, André Masson, Jean Arp, and Pablo Picasso. From the mid-twenties onward, Miró strove to leave direct objective references behind and developed the pictograms that typify his style. The pictures of this period, which include perhaps the most beautiful and significant ones of his whole œuvre, dispense with spatiality and an unambiguous reference to objects. From now on, the surfaces are defined by numerals, writing, abstract emblems, and playful figures and creatures. 1944 saw the beginning of his extensive graphic œuvre, ceramics, monumental mural works, and his sculptures. In these works too, the Catalan artist sought the solid foundation of a figurative, symbolic art with orientations as regards content: faces, stars, moons, rudimentary animal forms, letters. Joan Miró developed in several stages his characteristic flowing calligraphic style and his world of forms resembling shorthand symbols.

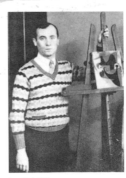

Joan Miró, 1931

Miró

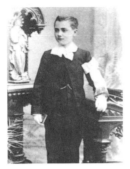

Joan Miró at the age of seven.

Joan Miró (1893–1983) is one of the most significant Spanish painters of our century.

His early work clearly shows the influence of Fauvism and Cubism. The Catalan landscape also shapes the themes and treatment of these initial works. In his travels Miró encountered the intellectual avant-garde of his time. His friends included Francis Picabia, Tristan Tzara, André Masson, Jean Arp, and Pablo Picasso. From the mid-twenties onward, Miró strove to leave direct objective references behind and developed the pictograms that typify his style. The pictures of this period, which include perhaps the most beautiful and significant ones of his whole œuvre, dispense with spatiality and an unambiguous reference to objects. From now on, the surfaces are defined by numerals, writing, abstract emblems, and playful figures and creatures. 1944 saw the beginning of his extensive graphic œuvre, ceramics, monumental mural works, and his sculptures. In these works too, the Catalan artist sought the solid foundation of a figurative, symbolic art with orientations as regards content: faces, stars, moons, rudimentary animal forms, letters. Joan Miró developed in several stages his characteristic flowing calligraphic style and his world of forms resembling shorthand symbols.

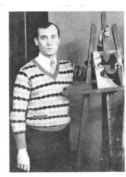

Joan Miró, 1931

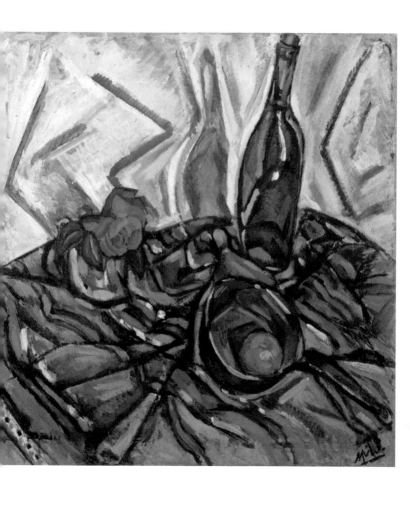

Joan Miró: Still Life with Rose, 1916
Stilleben mit Rose/La Rose
Switzerland, Private Collection

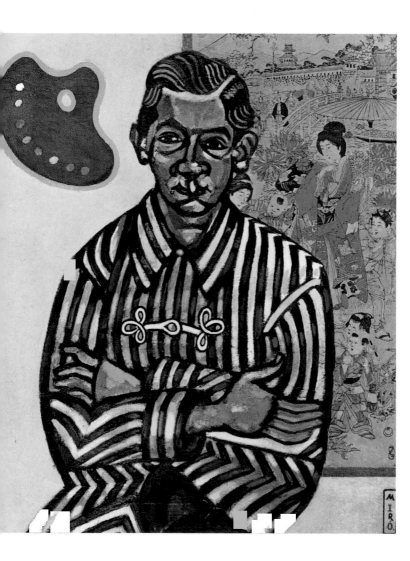

Joan Miró: Portrait of E. C. Ricart, 1917
Bildnis E. C. Ricart/Portrait de E. C. Ricart
Chicago, Marx Collection

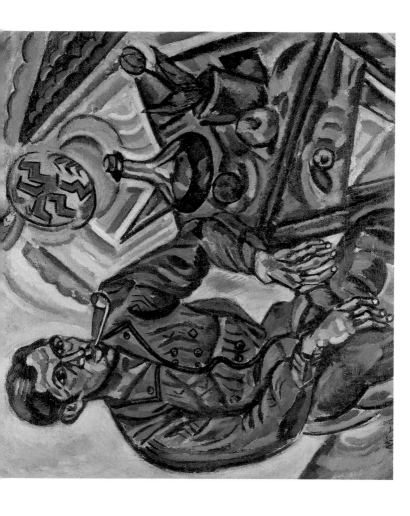

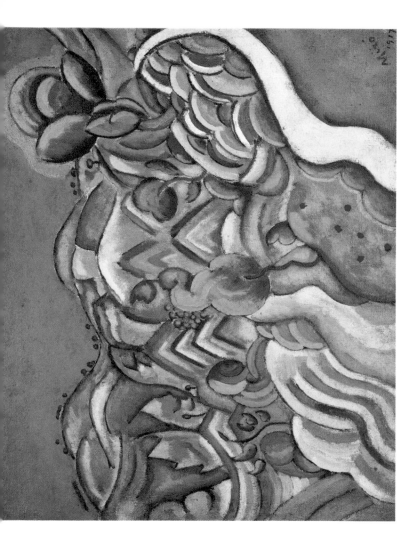

Joan Miró: Ciurana, the Path, 1917
Ciurana, der Pfad/Ciurana, e sentier
Paris, Tappenbeck Collection

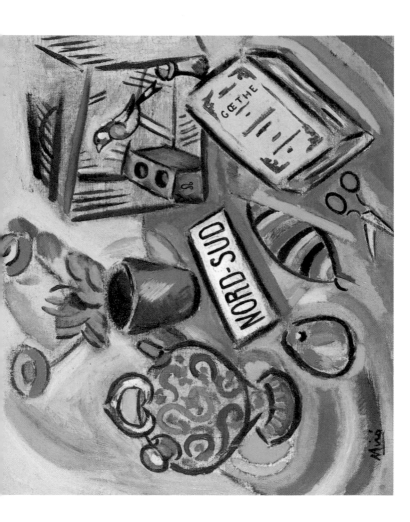

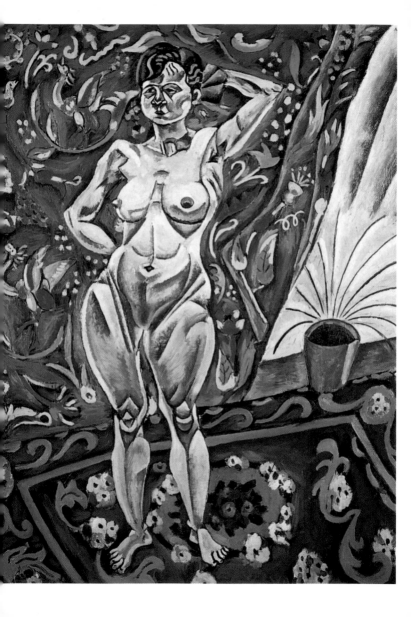

Joan Miró: Standing Nude, 1918
Stehender Akt/Nu debout
Saint Louis, The St. Louis Art Museum, Purchase: Friends Fund

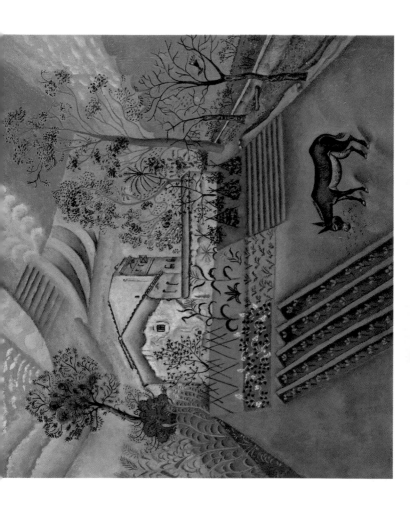

Joan Miró: Vegetable Garden with Donkey, 1918
Gemüsegarten mit Esel/Le Potager à l'âne
Stockholm, Moderna Museet

© 1993 Benedikt Taschen Verlag GmbH, Köln

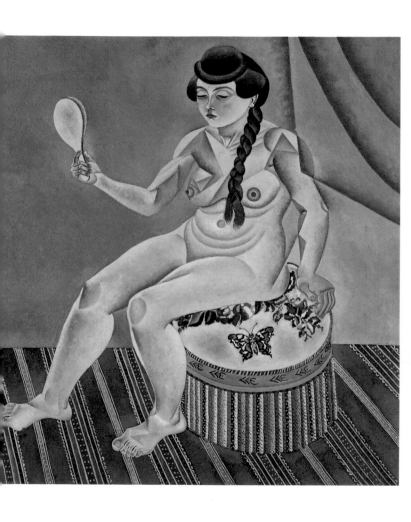

Joan Miró: Nude with Mirror, 1919
Akt mit Spiegel/Nu au miroir
Düsseldorf, Kunstsammlung Nordrhein-Westfalen

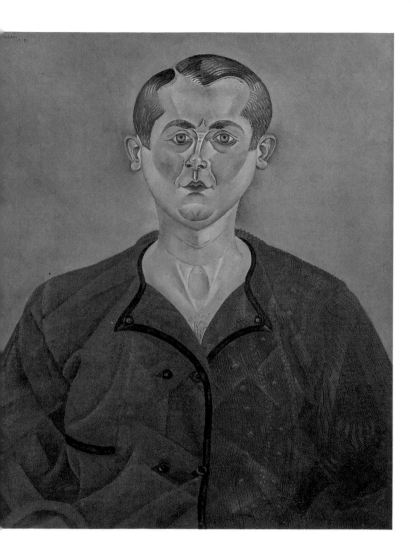

© 1993 Benedikt Taschen Verlag GmbH, Köln

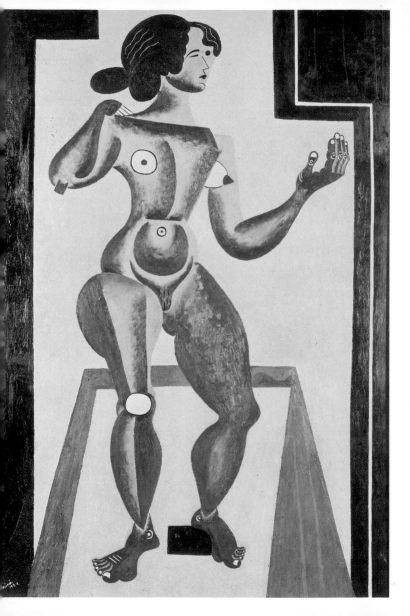

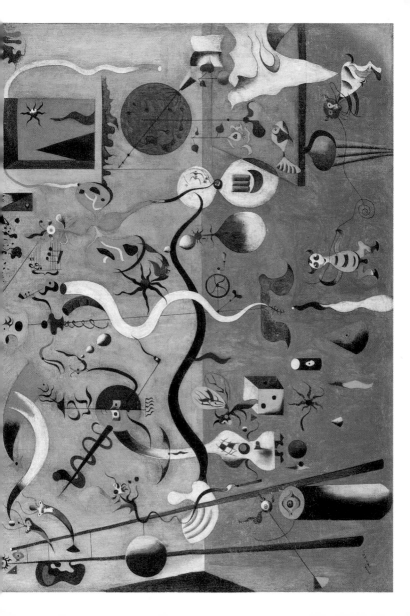

Joan Miró: The Harlequin's Carnival, 1924/25
Karneval des Harlekins/Le Carnaval d'Arlequin
Buffalo, N.Y., Albright-Knox Art Gallery
Room of Contemporary Art Fund 1940

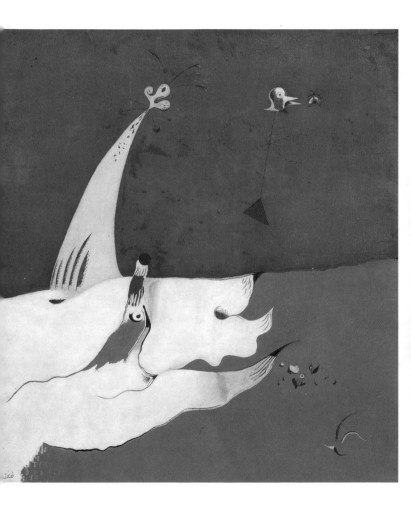

Joan Miró: Landscape, 1924/25
Landschaft/Paysage
Essen, Museum Folkwang

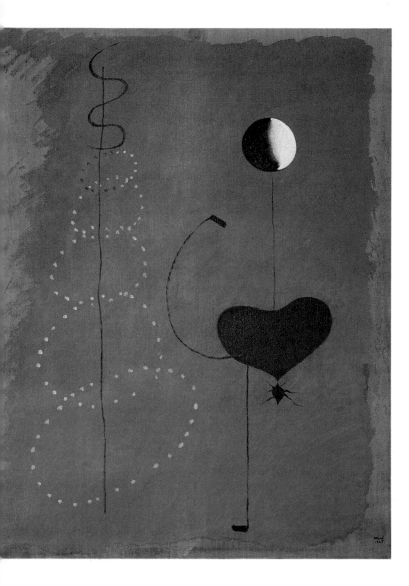

Joan Miró: Dancer, 1925
Tänzerin/Danseuse
Lucerne, Galerie Rosengart

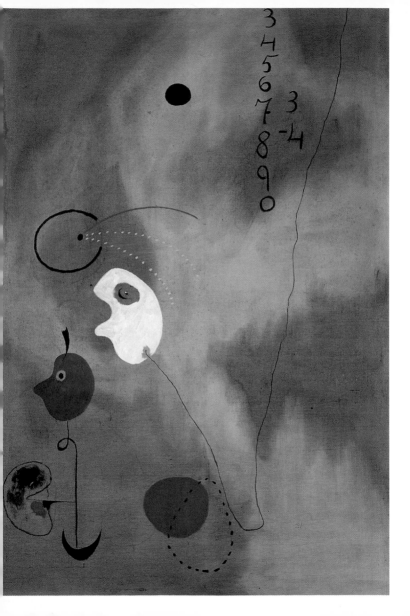

Joan Miró: The Bill, 1925
Die Rechnung/L'Addition
Paris, Musée National d'Art Moderne, Centre Georges Pompidou

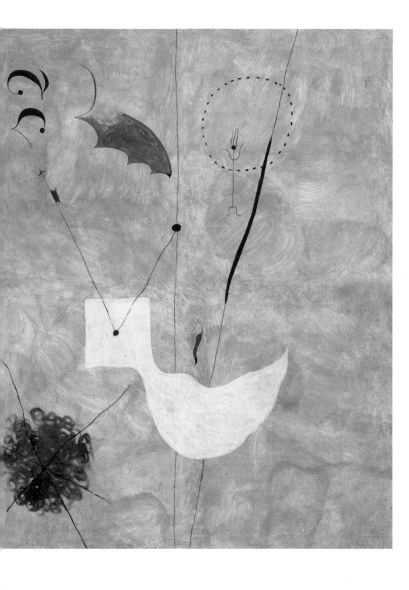

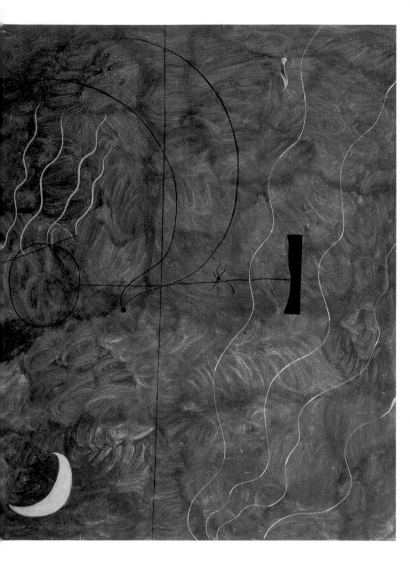

Joan Miró: Woman Bathing, 1925
Badende/Baigneuse
Paris, Musée National d'Art Moderne, Centre Georges Pompidou

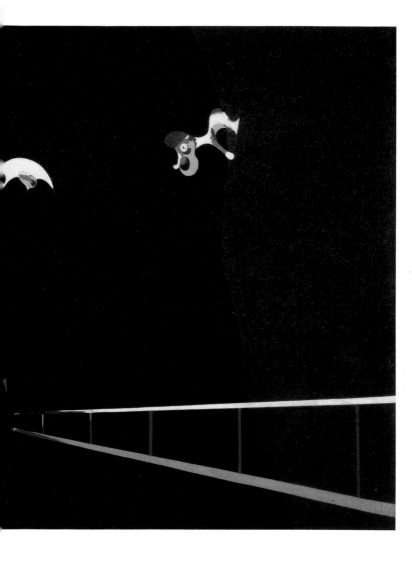

Joan Miró: Dog Barking at the Moon, 1926
Hund, den Mond anbellend/Chien aboyant à la lune
Philadelphia, The Philadelphia Museum of Art:
A. E. Gallatin Collection

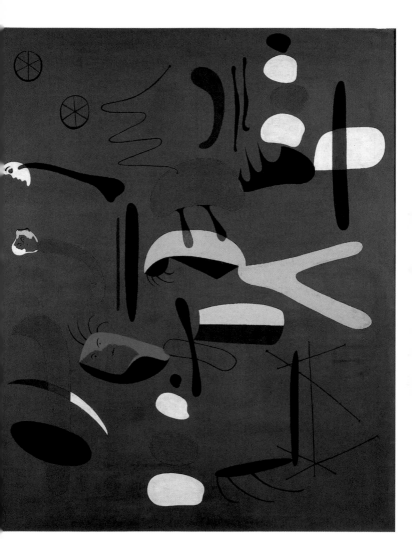

Joan Miró: Painting, 1933
Malerei/Peinture
Barcelona, Fundació Joan Miró

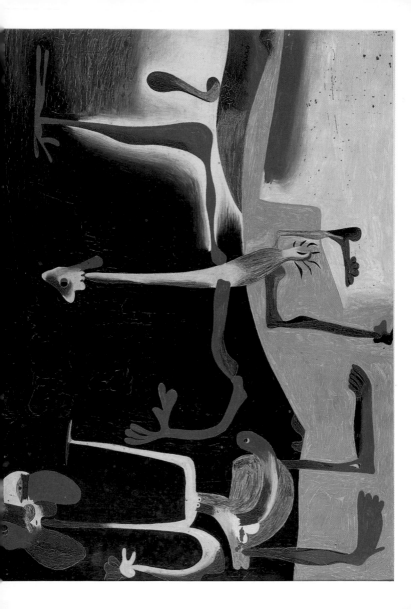

Joan Miró: Man and Woman in Front of a Pile of Excrement, 1936
Mann und Frau vor einem Kothaufen/Homme et femme devant un tas
d'excréments
Barcelona, Fundació Joan Miró

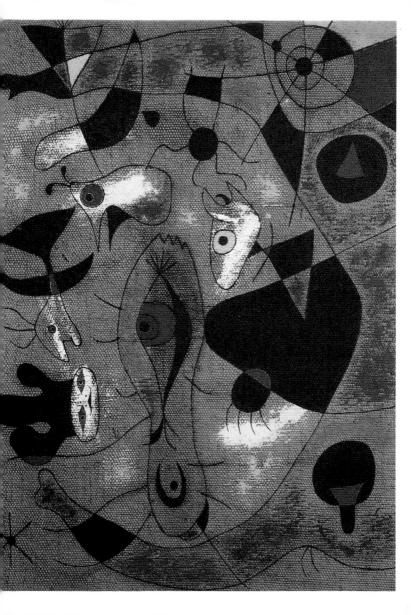

Joan Miró: A Dew Drop Falling from a Bird's Wing Wakes Rosalie, Who Has Been Asleep in the Shadow of a Spider's Net. 1939
Ein Tautropfen, der von dem Flügel eines Vogels fällt, weckt die im Schatten eines Spinnennetzes schlummernde Rosalie./Une goutte de rosée tombant de l'aile d'un oiseau réveille Rosalie endormie à l'ombre d'une toile d'araignée
Iowa, The University of Iowa Museum of Art, The Mark Ranney Memorial Fund

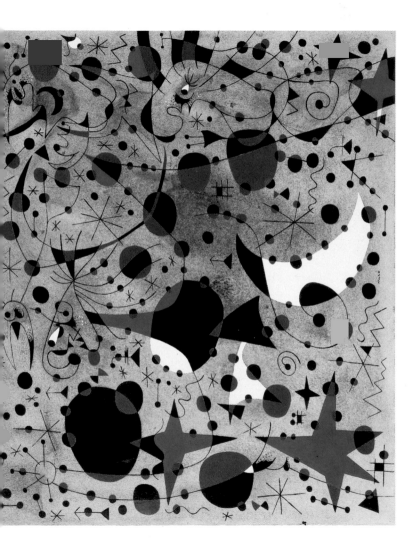

Joan Miró: The Nightingale's Song at Midnight and the Morning Rain, 1940
Das Lied der Nachtigall um Mitternacht und der Morgenregen/Le Chant du
rossignol à minuit et la pluie matinale
New York, Perls Galleries

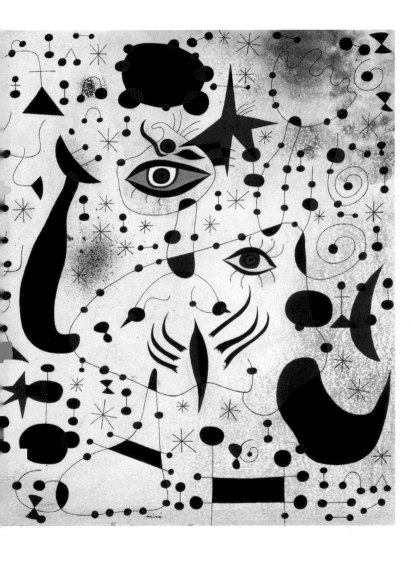

Joan Miró: Ciphers and Constellations in Love with a Woman, 1941
Ziffern und Sternbilder, in eine Frau verliebt/Chiffres et constellations
amoureux d'une femme
Chicago, The Art Institute of Chicago

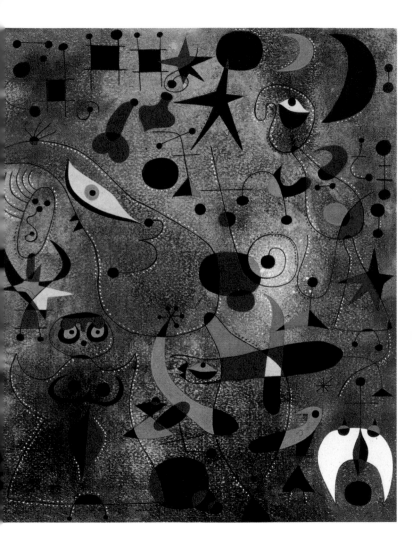

Joan Miró: Constellation: Awakening at Dawn, 1941
Erwachen im Morgengrauen/Le Réveil au petit jour
New York, Private Collection

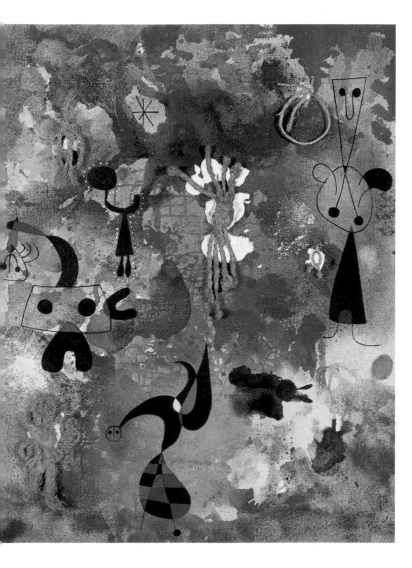

Joan Miró: Painting, 1950
Malerei/Peinture
Eindhoven, Stedelijk van Abbemuseum

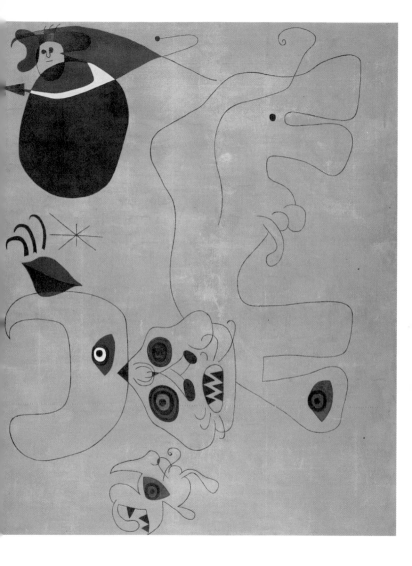

Joan Miró: The Bullfight, 1945
Der Stierkampf/La Course de taureaux
Paris, Musée National d'Art Moderne, Centre Georges Pompidou

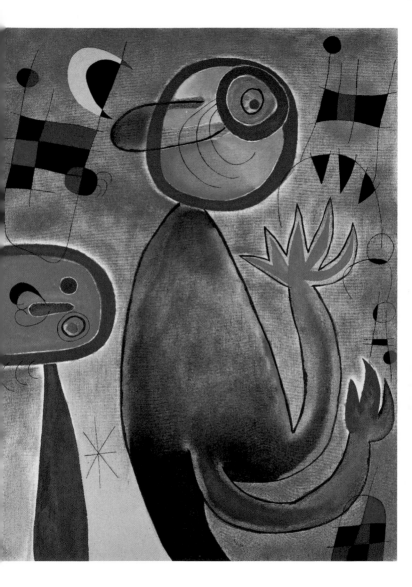

© 1993 Benedikt Taschen Verlag GmbH, Köln

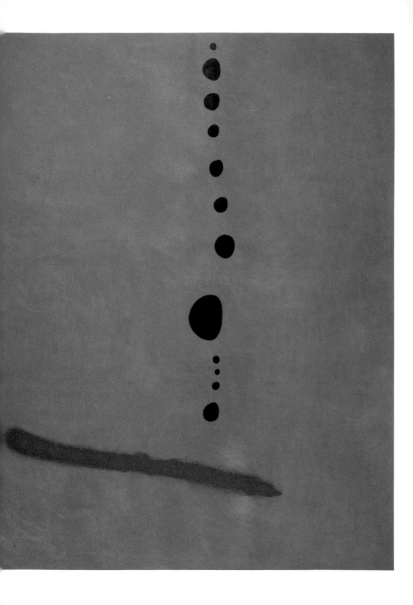

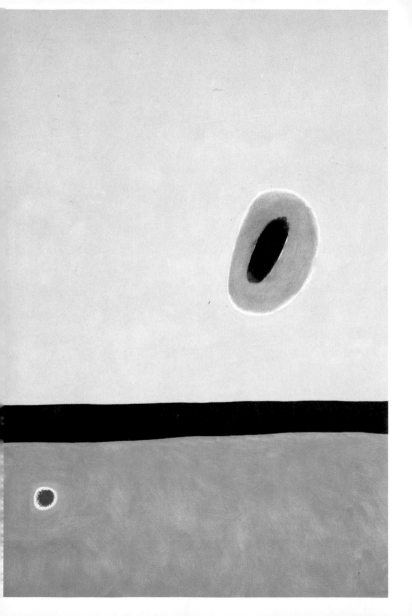

Joan Miró: The Lark's Wing, Encircled With Golden Blue, Rejoins the Heart
of the Poppy Sleeping on a Diamond-Studded Meadow, 1967
Der von Goldblau umkreiste Flügel der Lerche kommt wieder zum Herzen des
Klatschmohns, der auf der diamantengeschmückten Wiese schläf/L'aile de
l'alouette encerclée de bleu d'or rejoint le cœur du coquelicot qui dort sur la
prairie de diamants
Private Collection

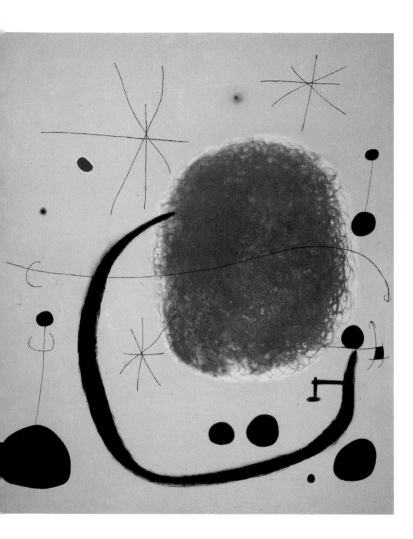

Joan Miró: The Gold of Azure, 1967
Das Gold des Himmelsblau/L'Or de l'azur
Barcelona, Fundació Joan Miró

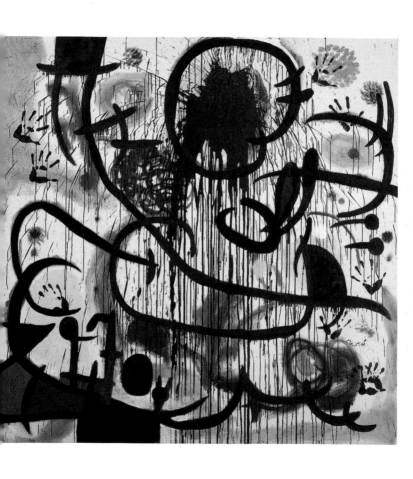

Joan Miró: May 1968, 1973
Mai 1968/Mai 1968
Barcelona, Fundació Joan Miró

Miró im Jahre 1945

Joan Miró (1893–1983) gehört zu den bedeutendsten spanischen Malern unseres Jahrhunderts.

Sein Frühwerk weist noch deutliche Einflüsse des Fauvismus und des Kubismus auf. Die ländliche katalanische Umgebung bestimmt Thematik und Ausformung des frühen Werks. Zu seinen Freunden zählte die intellektuelle Avantgarde der Zeit: Francis Picabia, Tristan Tzara, André Masson, Jean Arp und Pablo Picasso. Ab Mitte der 20er Jahre strebte Miró fort von den direkten gegenständlichen Bezügen und entwickelte die für ihn typischen Bildzeichen. Die Bilder dieser Zeit, die zu den schönsten des Gesamtwerkes zählen, verzichten auf Räumlichkeit und einen eindeutigen gegenständlichen Bezug. Die Fläche bestimmen Ziffern, Schrift, abstrakte Embleme und spielerische Figuren und Wesen. 1944 markiert den Wendepunkt seines Schaffens: Sein umfangreiches graphisches Œuvre, Keramiken, monumentale Wandgestaltungen und sein plastisches Werk entstehen. Auch in diesen Arbeiten suchte der Katalane den festen Grund einer figürlichen, symbolhaften Kunst mit inhaltlichen Orientierungen: Gesichter, Sterne, Monde, rudimentäre Tierformen, Buchstaben. Joan Miró entwickelte in mehreren Folgen den ihm eigenen fließenden kalligraphischen Stil und seine kürzelhafte Gestaltwelt.

Joan Miró, ca. 1950

Joan Miró, 1954

Joan Miró (1893–1983) est l'un des peintres espagnols les plus célèbres du 20ème siècle.

Le Fauvisme et le Cubisme ont nettement influencé l'œuvre précoce de Miró et les paysages catalans de sa terre natale en imprègnent les thèmes et les formes. Au cours de ses voyages le peintre a rencontré l'avant-garde intellectuelle de l'époque. Francis Picabia, Tristan Tzara, André Masson, Jean Arp et Pablo Picasso étaient ses amis. Vers 1925 Miró cesse de s'intéresser à la représentation de l'objet et crée les signes picturaux que nous connaissons. Les peintures de cette époque, peut-être les plus belles et les plus importantes de son œuvre, renoncent à toute spatialité et à toute référence figurative. Par la suite la surface des toiles sera déterminée par des chiffres, des signes d'écriture, des emblèmes abstraits, des personnages et des entités ludiques. A partir de 1944 on voit apparaître son œuvre graphique et plastique, des céramiques, des réalisations murales monumentales. Ici aussi Miró recherche la base solide d'un art imagé, riche en symboles féconds: des visages, des étoiles, des lunes, des formes animales rudimentaires, des lettres. Joan Miró a développé en plusieurs étapes le style calligraphique mouvant et ce monde de silhouettes à peine esquissées qui l'ont rendu célèbre.

Joan Miró, 1958